Sappho in Art

Edited by Linda Savage

ASPIRATION

I do not think with my two arms to touch the sky,
I do not dream to do almighty things;
So small a singing bird may never soar so high,
To beat the sapphire fire with baffled wings.

I do not think with my two arms to touch the sky,
I do not dream by any chance to share
With deathless Gods the bliss of Paphos they deny
To men behind the azure veil of air.

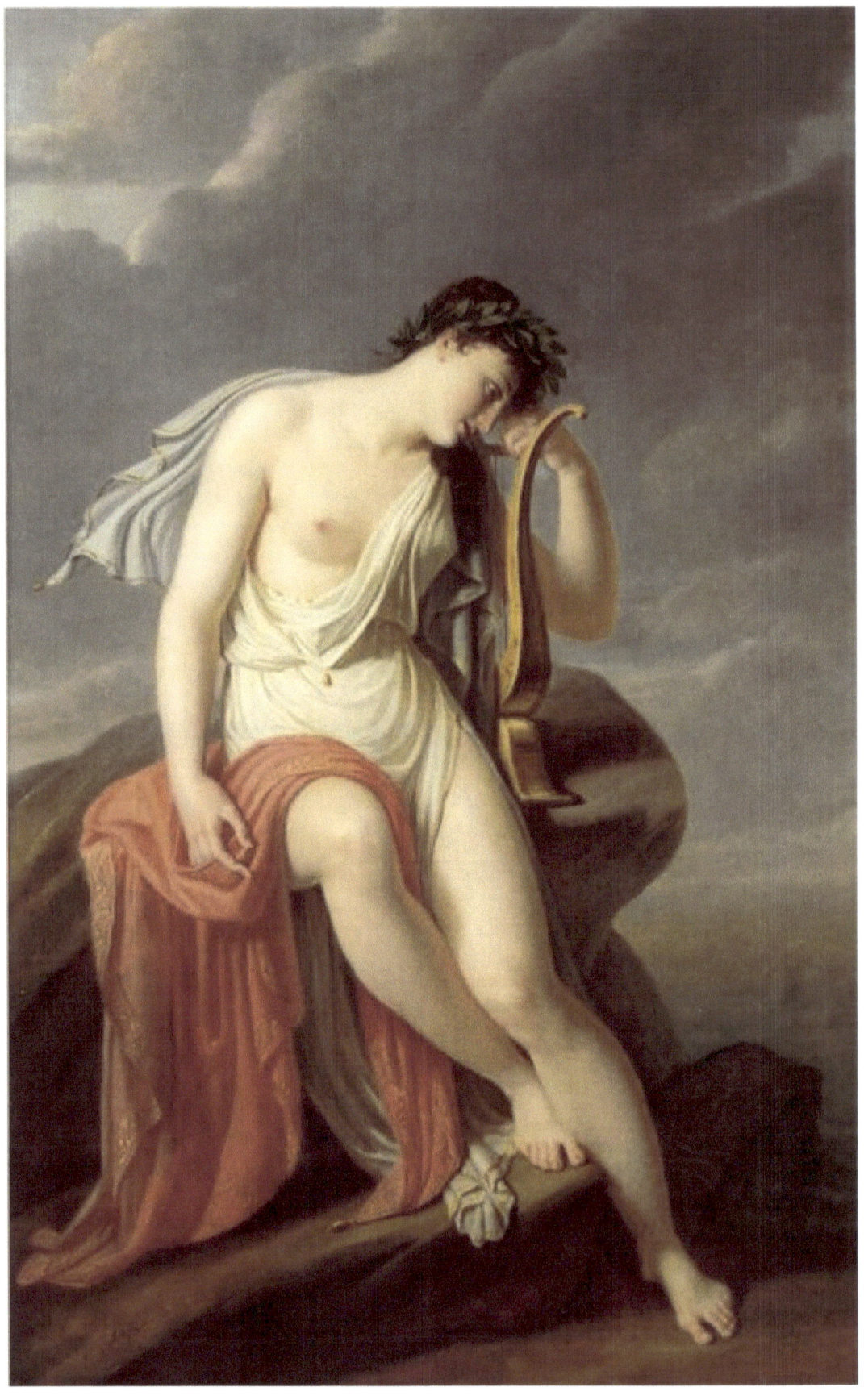

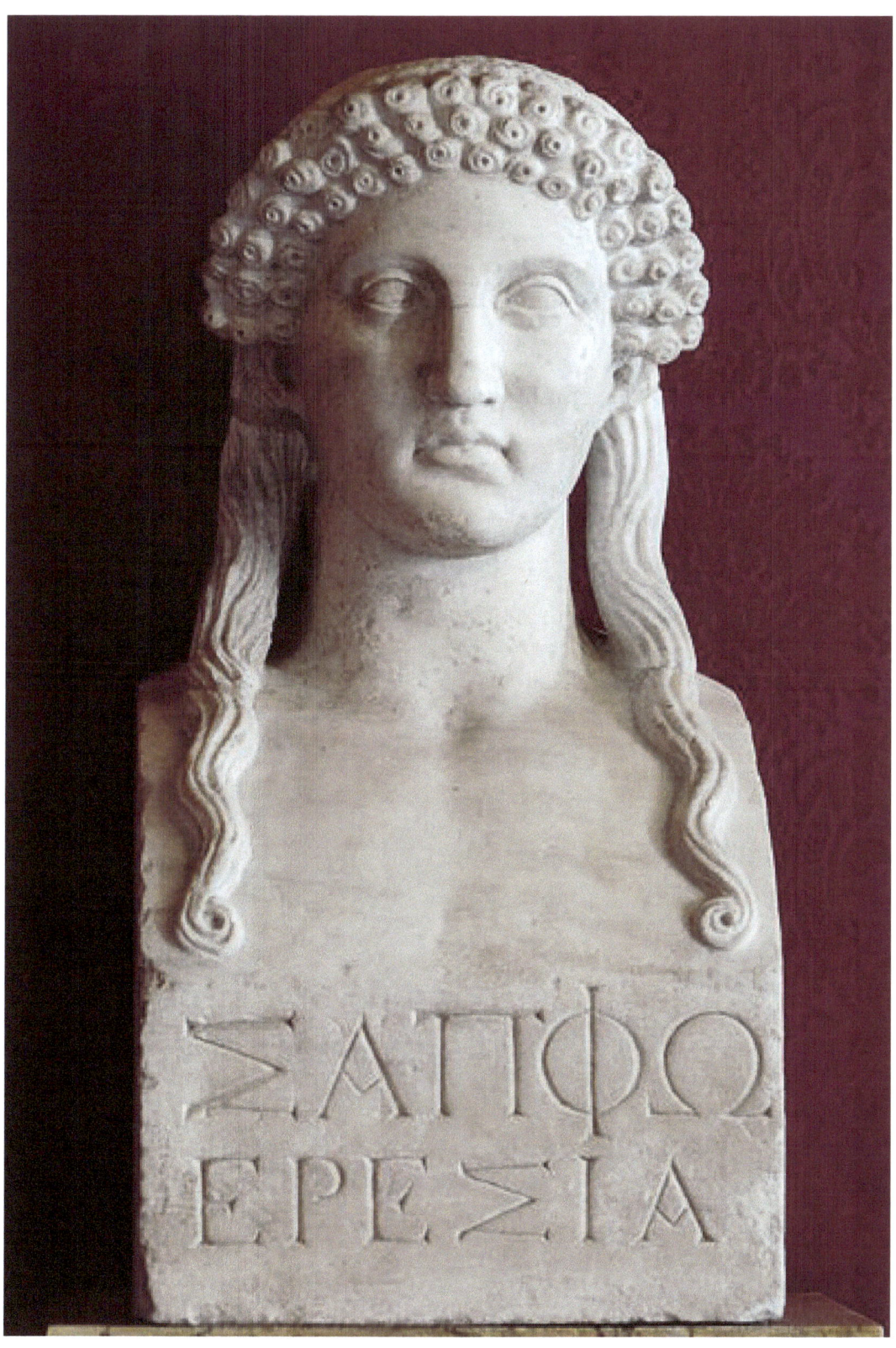

Bust inscribed Sappho of Eressos, Roman copy of a Greek original of the 5th century BCE

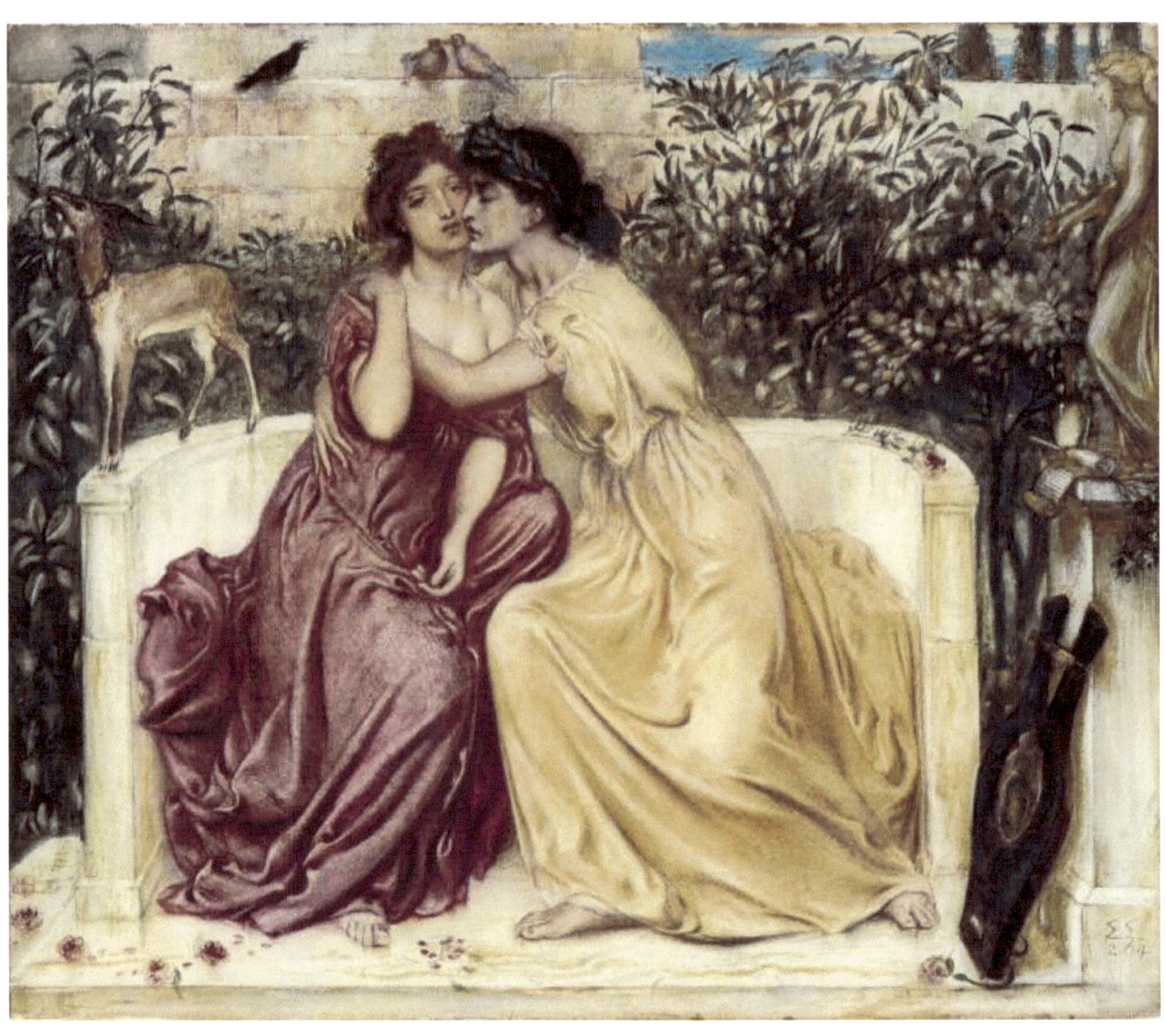

Sappho and Erinna in a Garden at Mytilene-- Simeon Solomon—1864

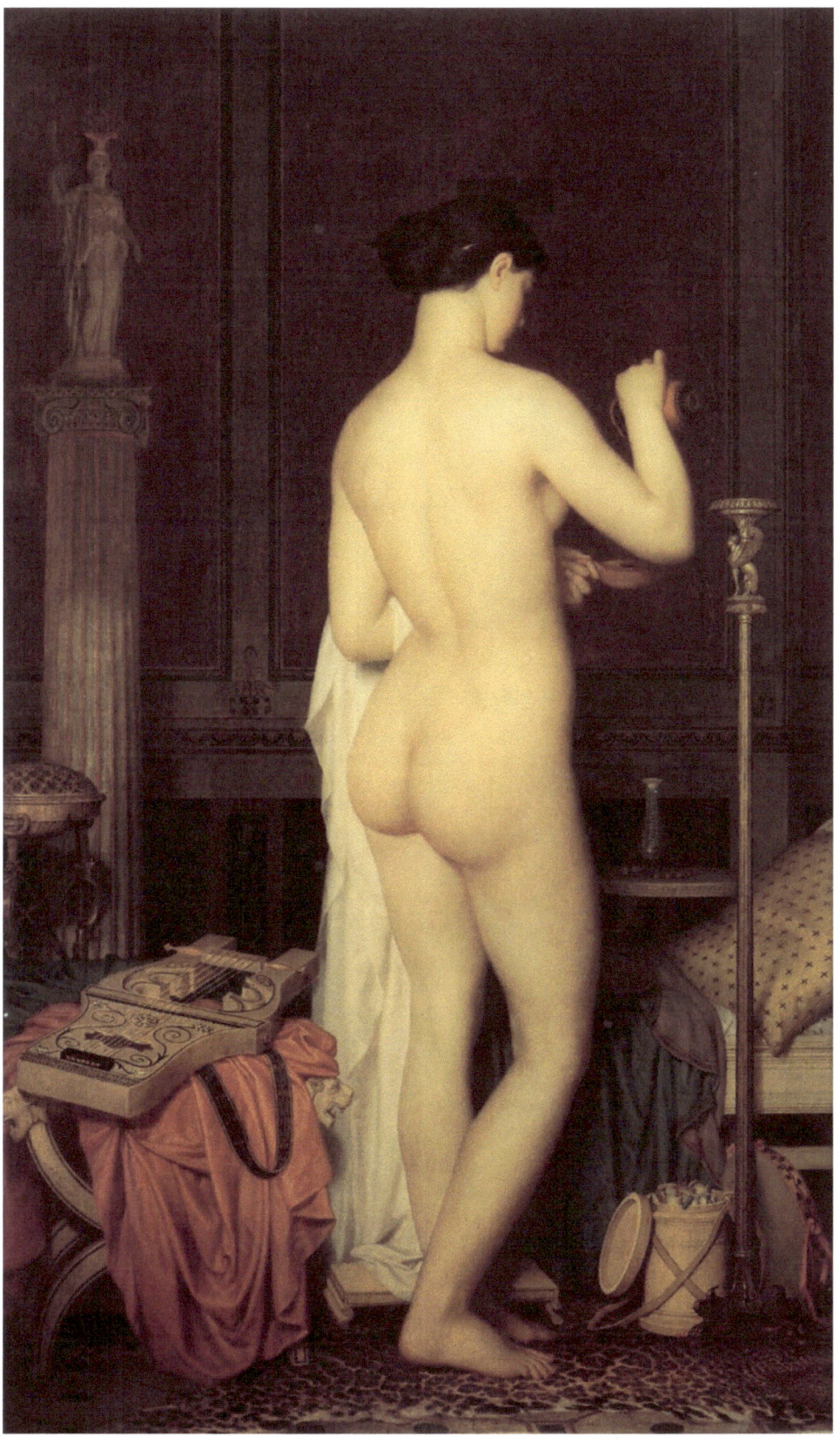

Gleyre Le Coucher de Sappho-- Marc-Charles-Gabriel Gleyre

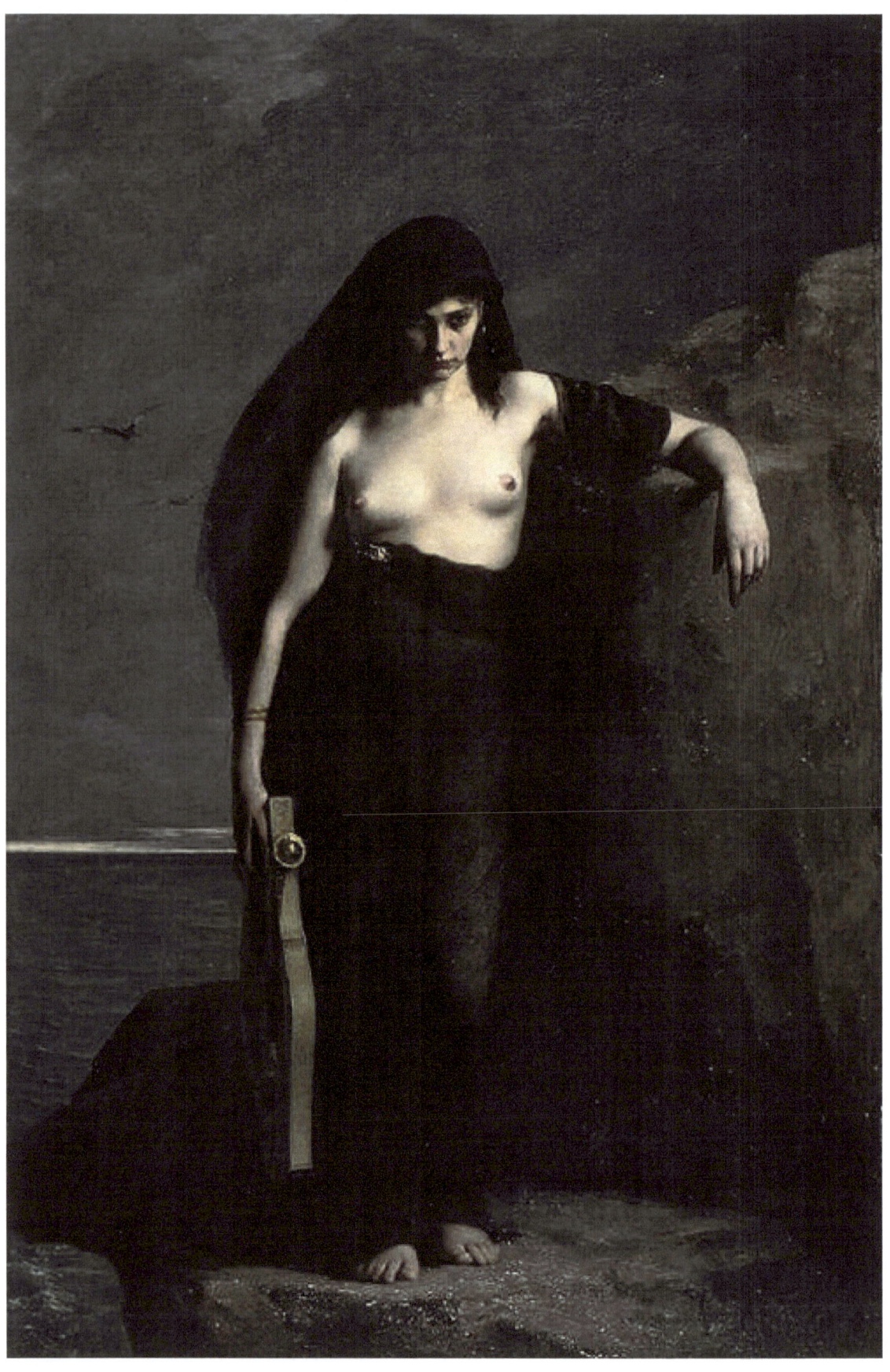

"Sappho," Charles August Mengin--1877

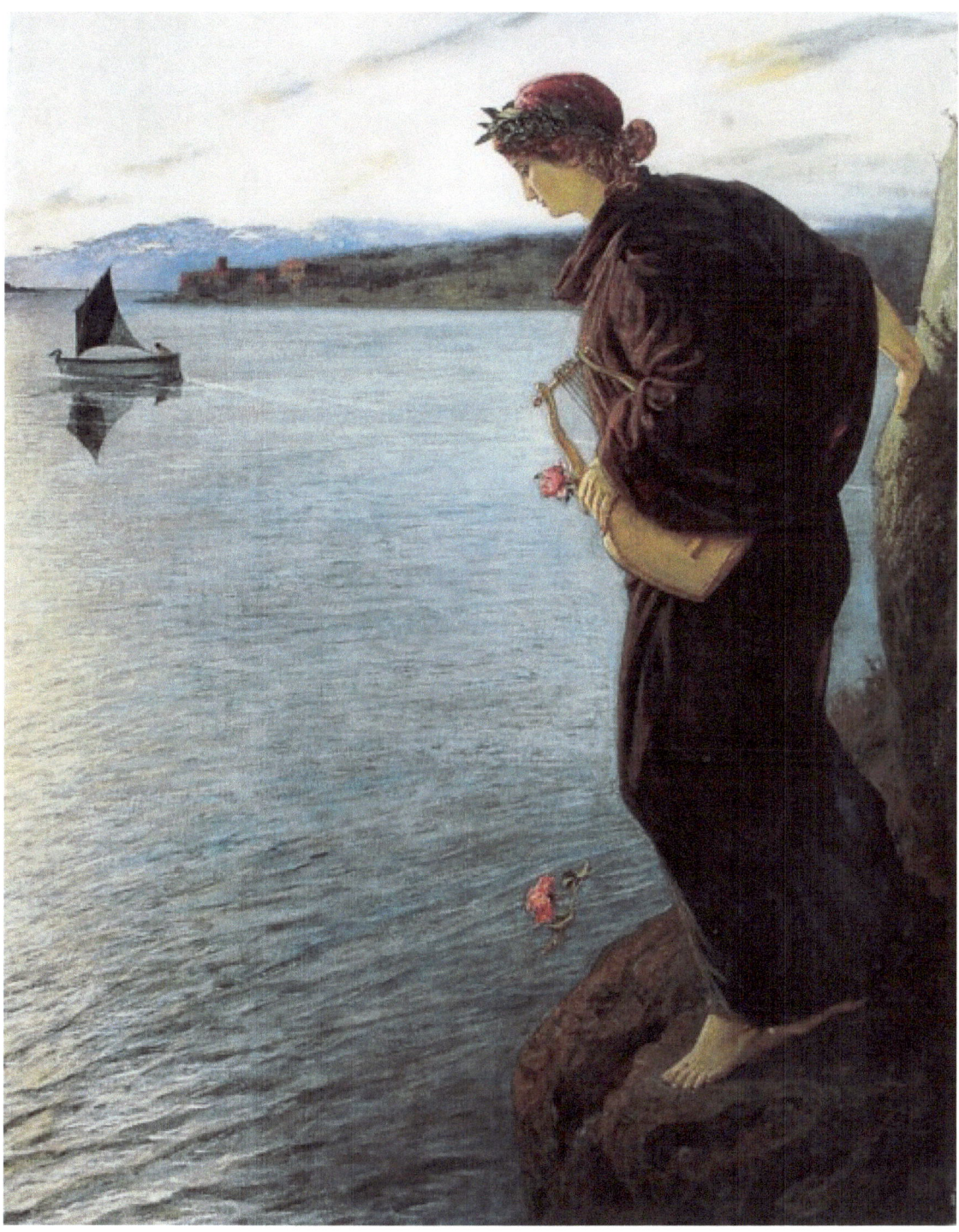
"Sappho" --Ernst Stückelberg--1897

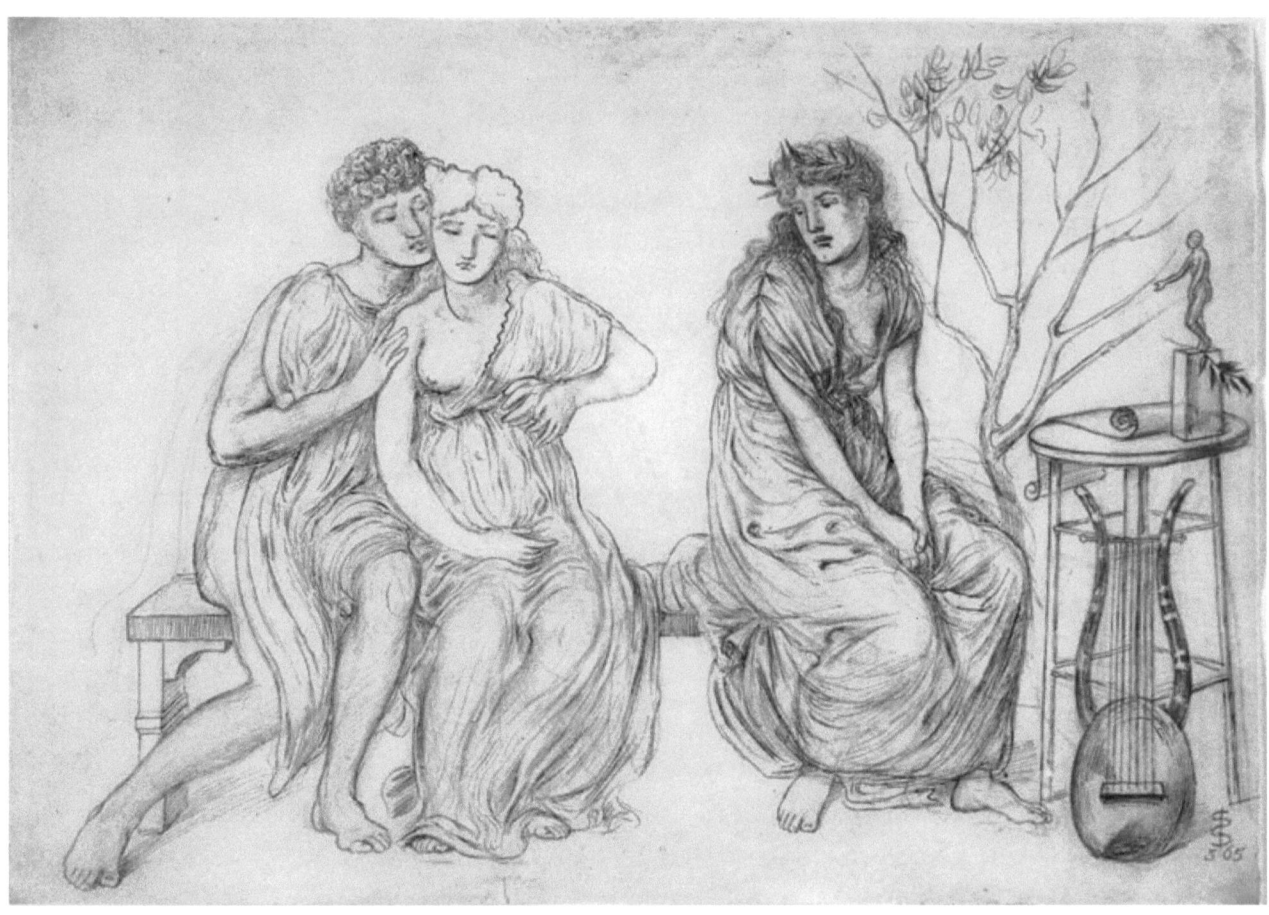

"Erinna Taken from Sappho"—1865--Simeon Solomon (1840-1905)

LONG AGO

Long ago beloved, thy memory, Atthis,
Saddens still my heart as the soft Æolic
Twilight deepens down on the sea, and fitful
Winds that have wandered

Over groves of myrtle at Amathonte
Waft forgotten passion on breaths of perfume.
Long ago, how madly I loved thee, Atthis!
Faithless, light-hearted

Loved one, mine no more, who lovest another
More than me; the silent flute and the faded

Garlands haunt the heart of me thou forgettest,
Long since thy lover.

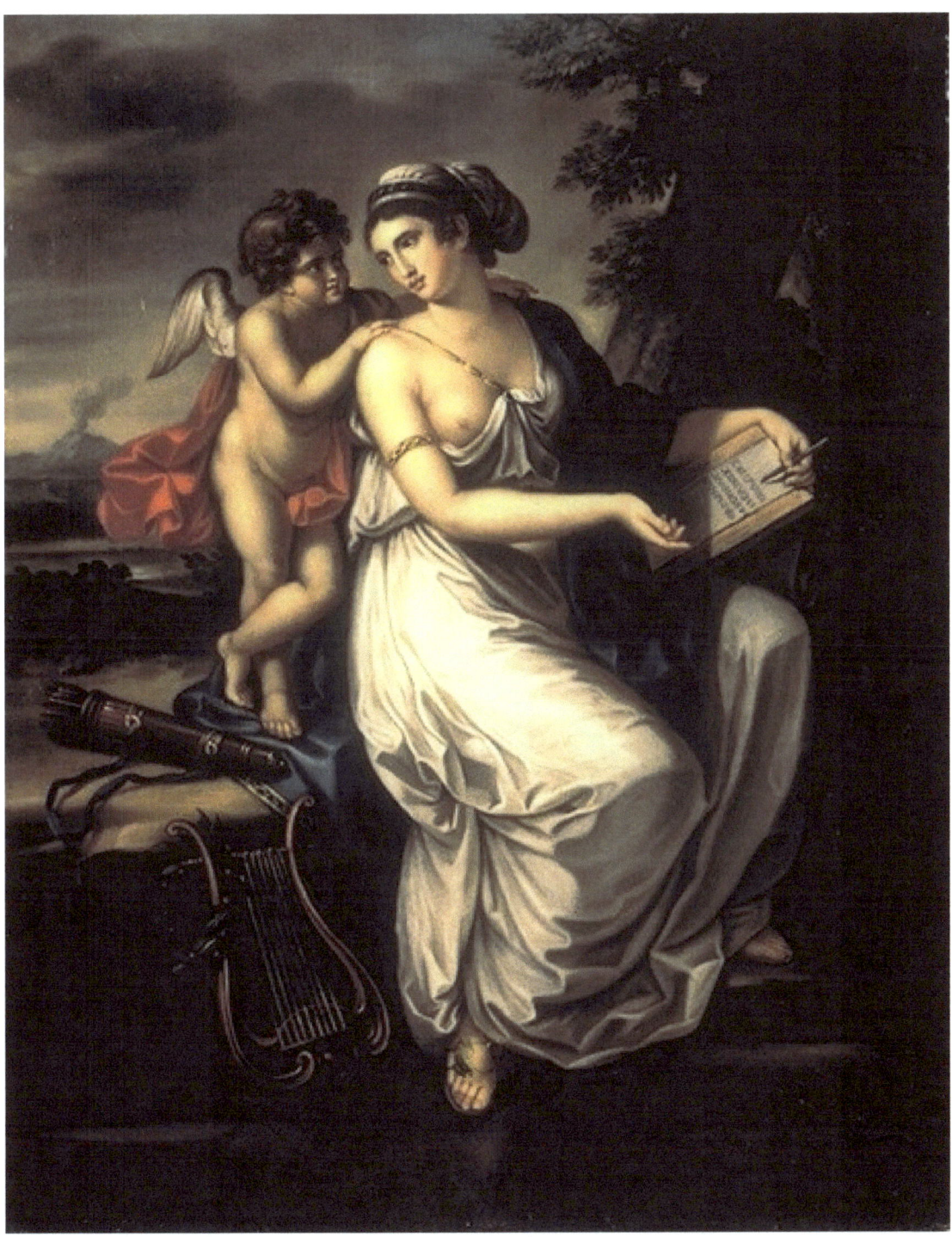

Sappho und Amor --Angelica Kauffmann (1741-1807)

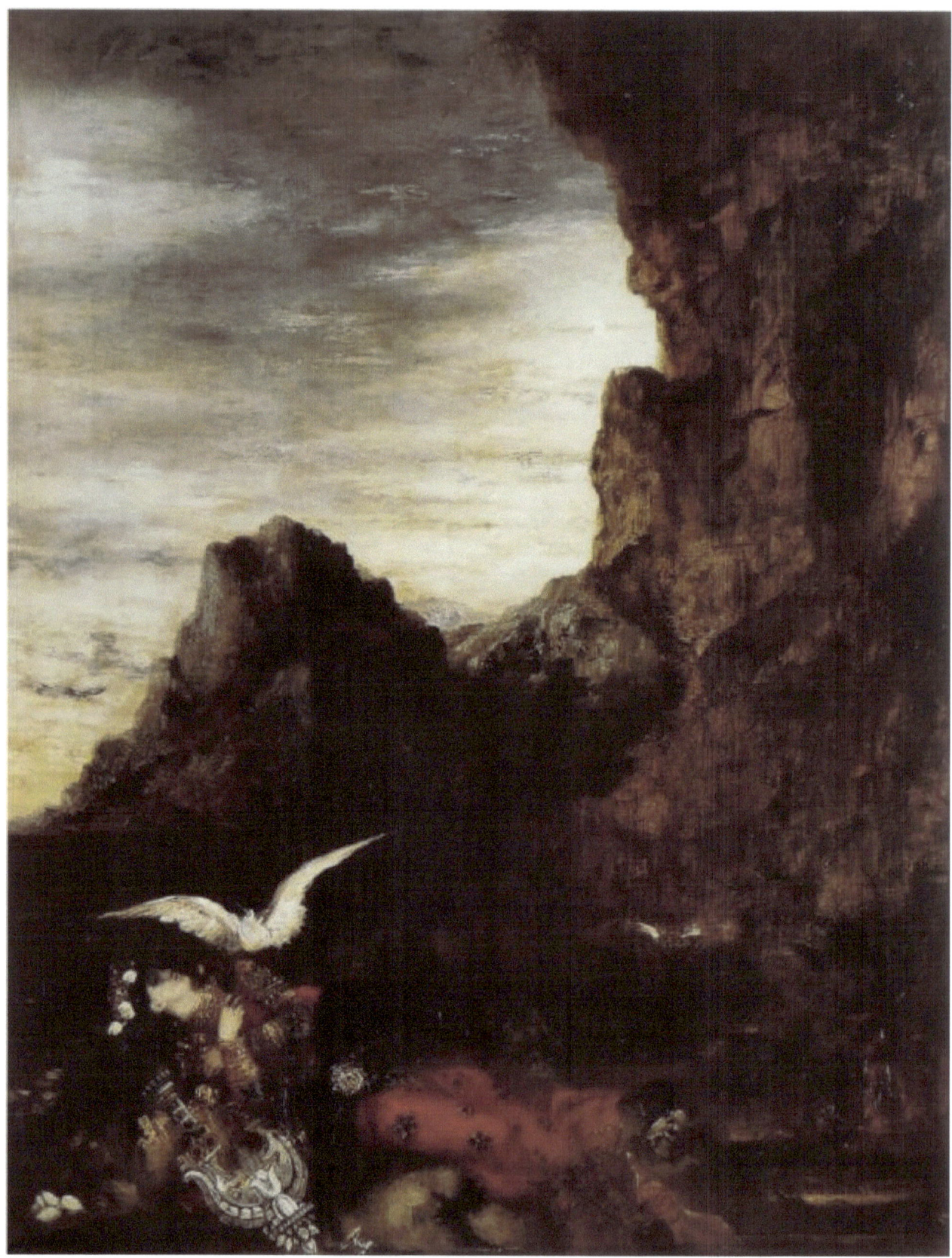

Death of Sappho-- Gustave Moreau--1870

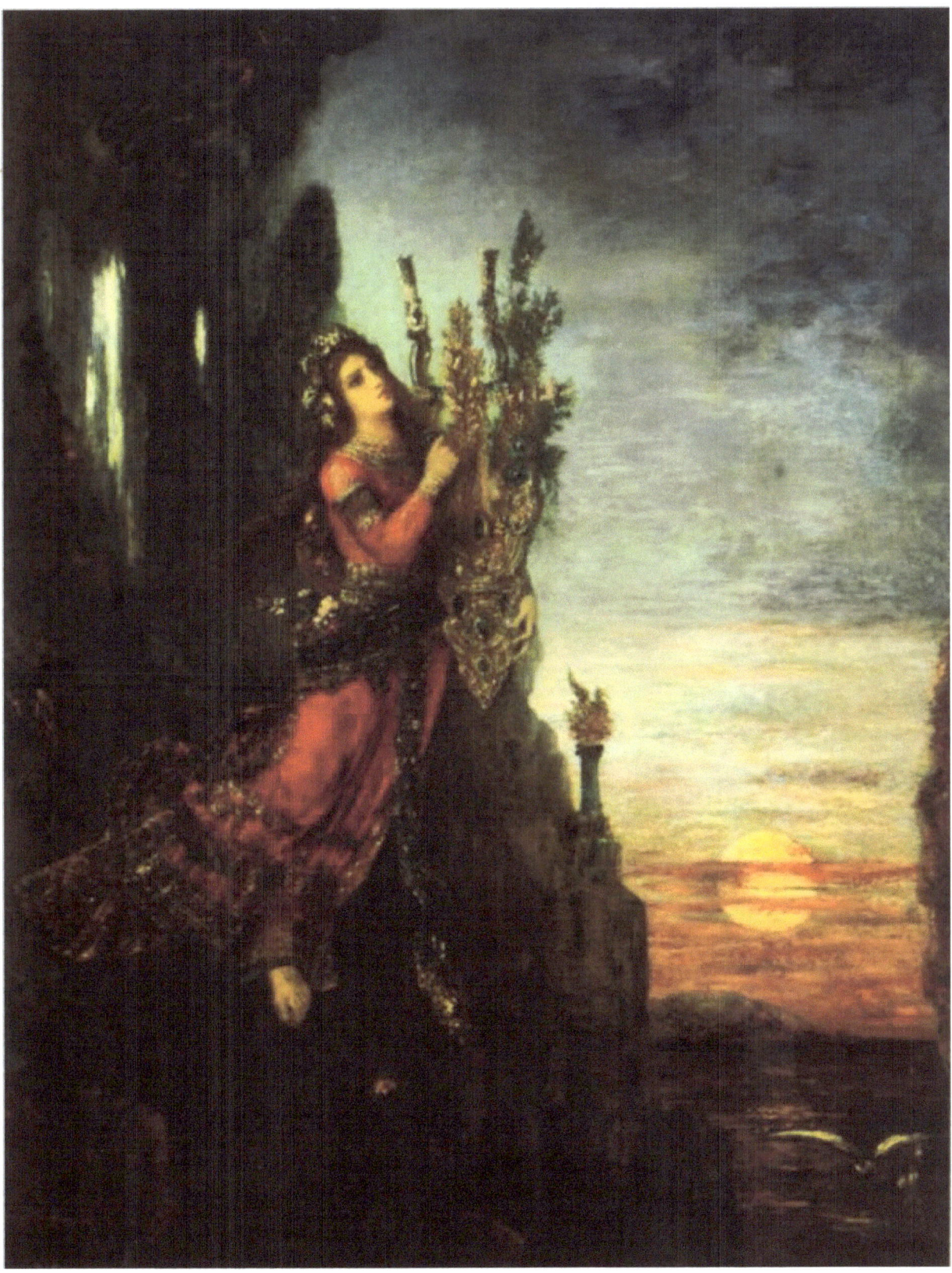

Sappho-- Gustave Moreau--1893

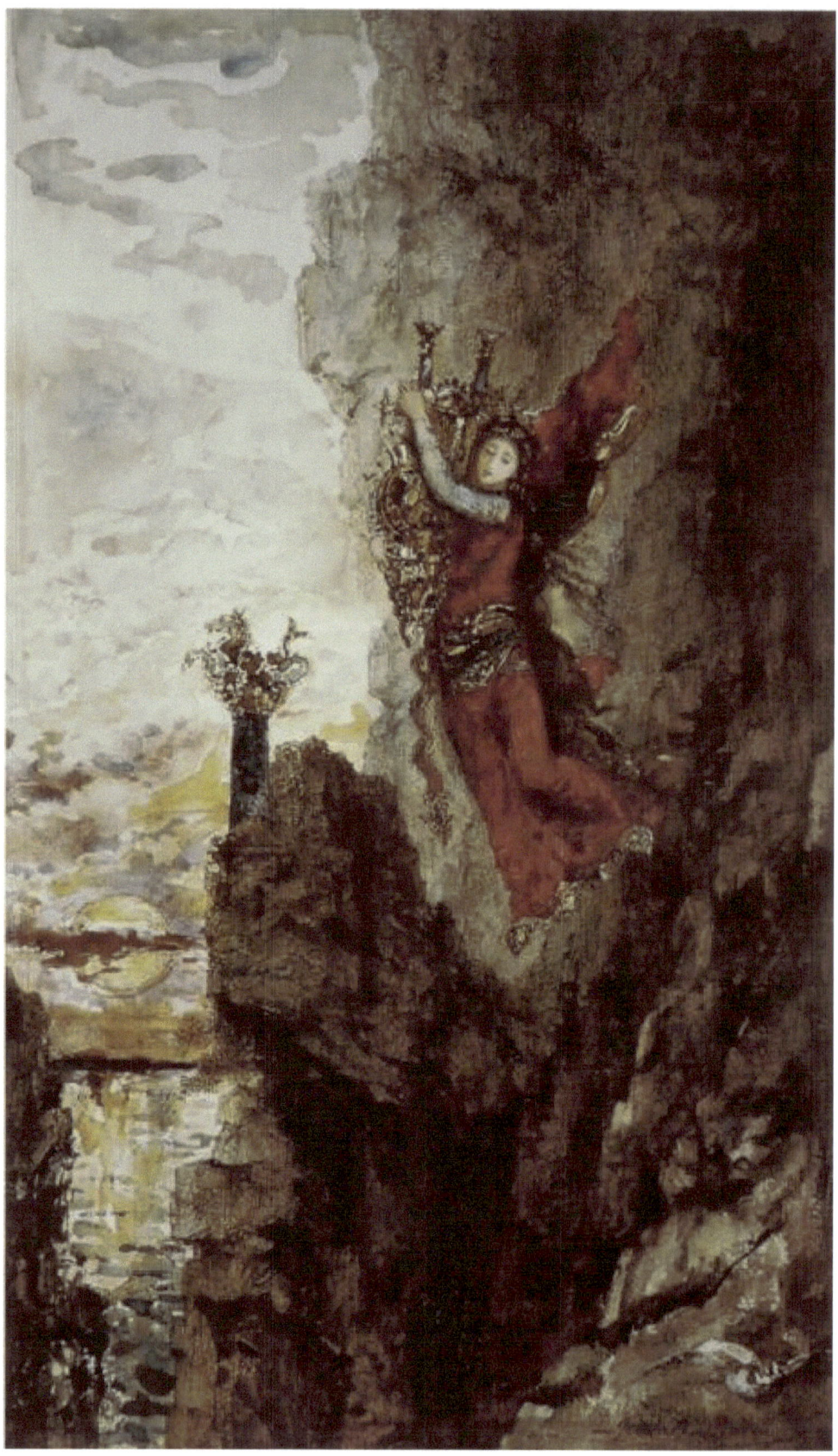

Sappho in Leucadia-- Gustave Moreau

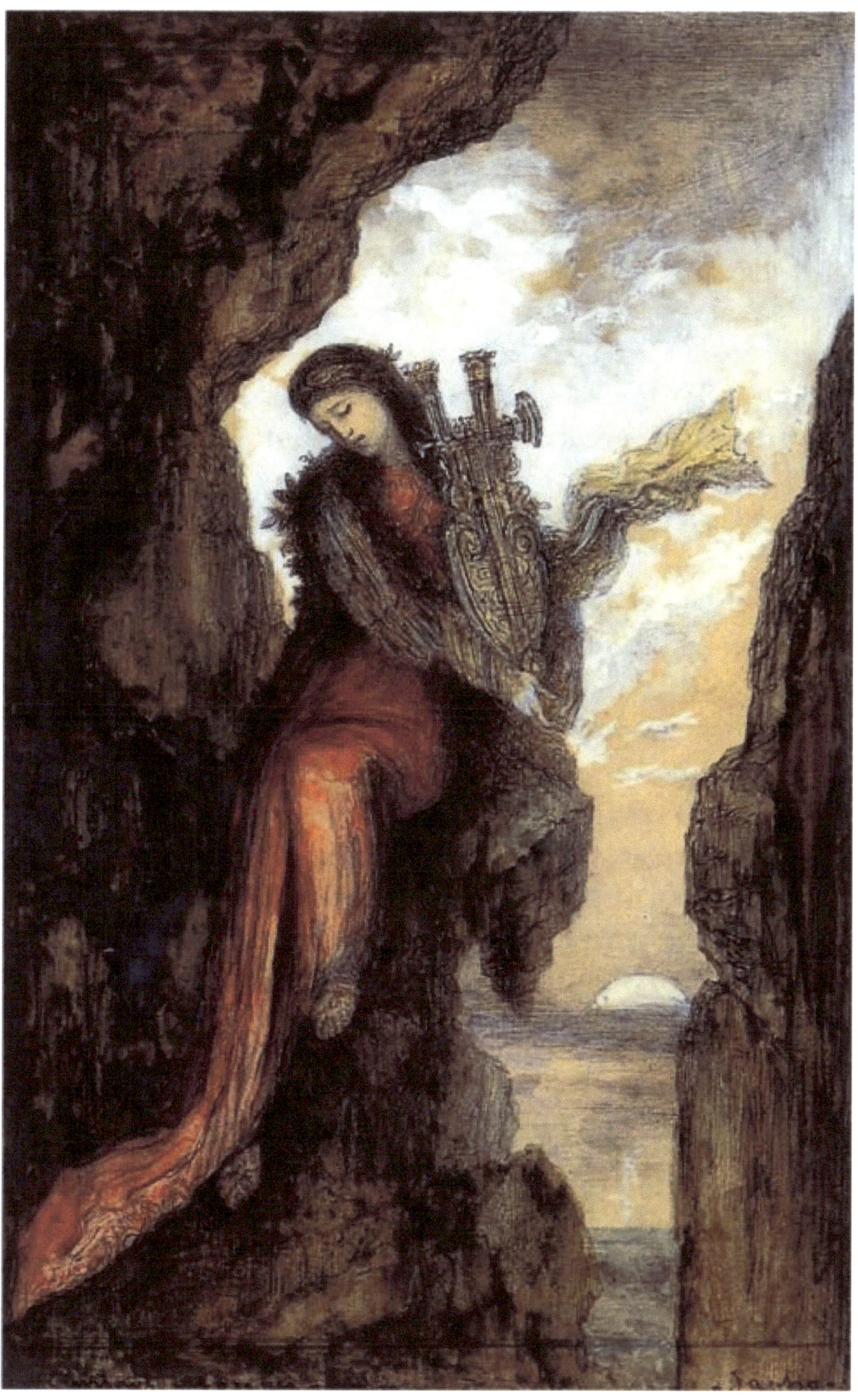

Sappho on the Cliff --Gustave Moreau--1872

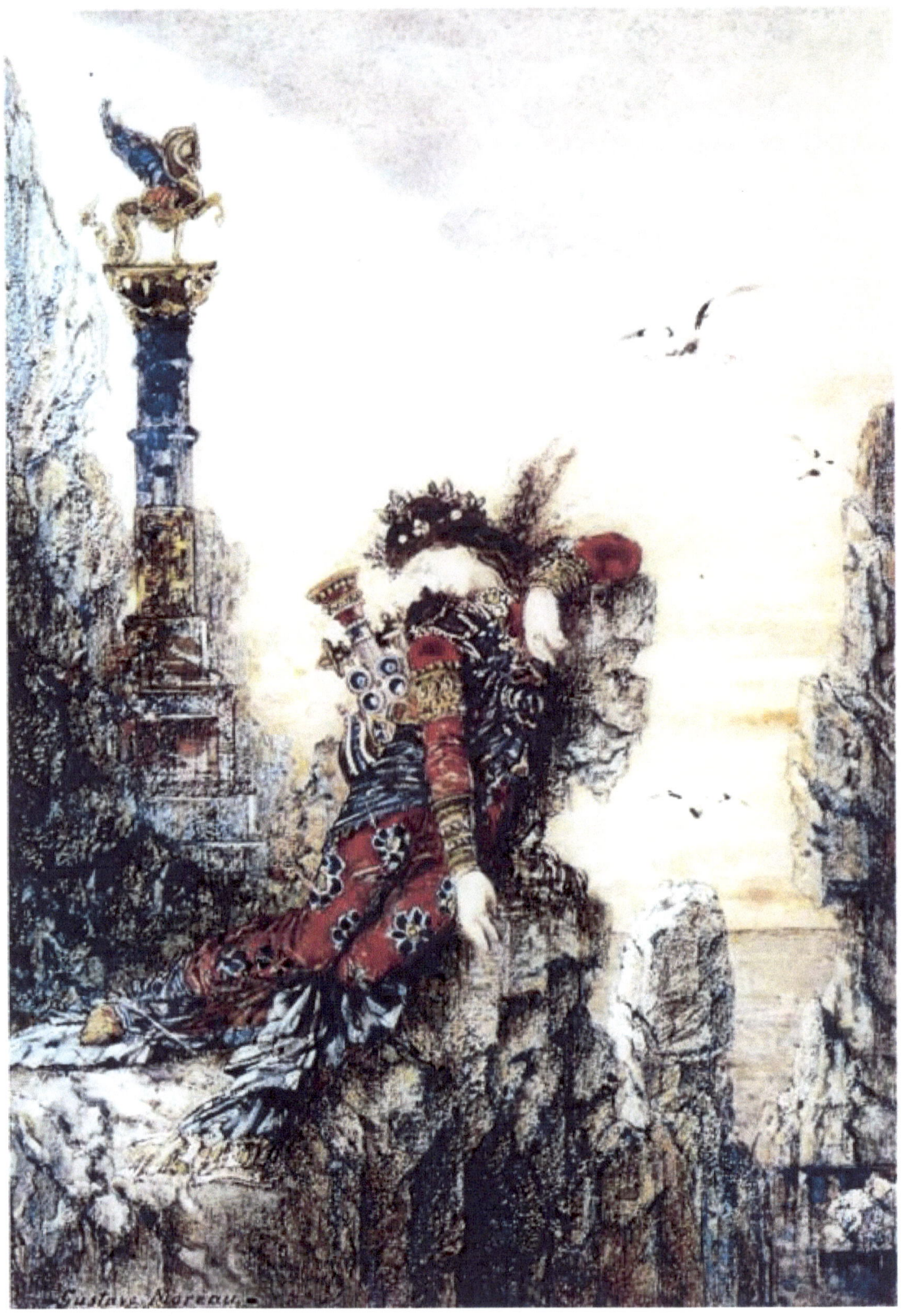

Sappho on the Rocks--Gustave Moreau --1869

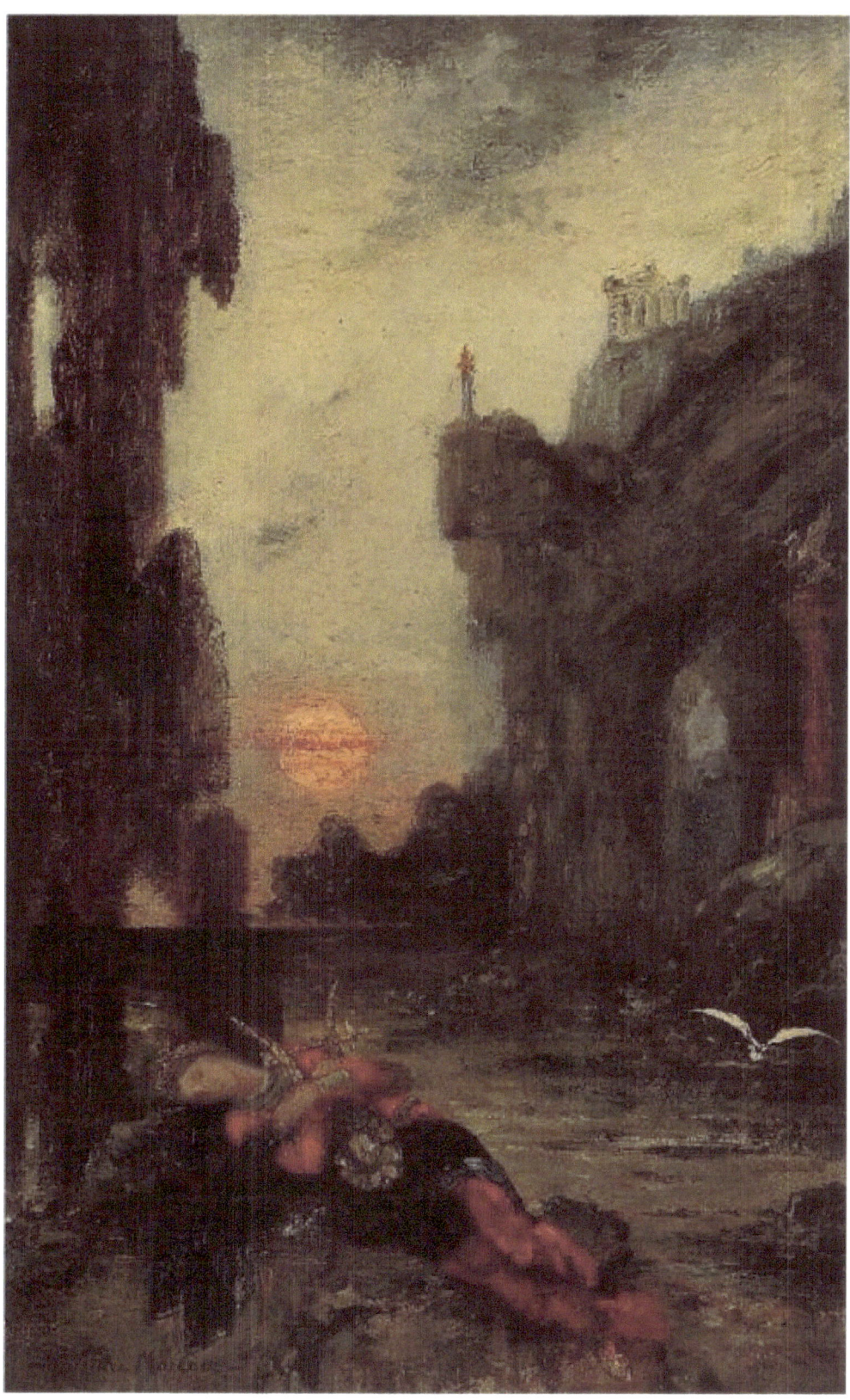

The Death of Sappho--Gustave Moreau--1872

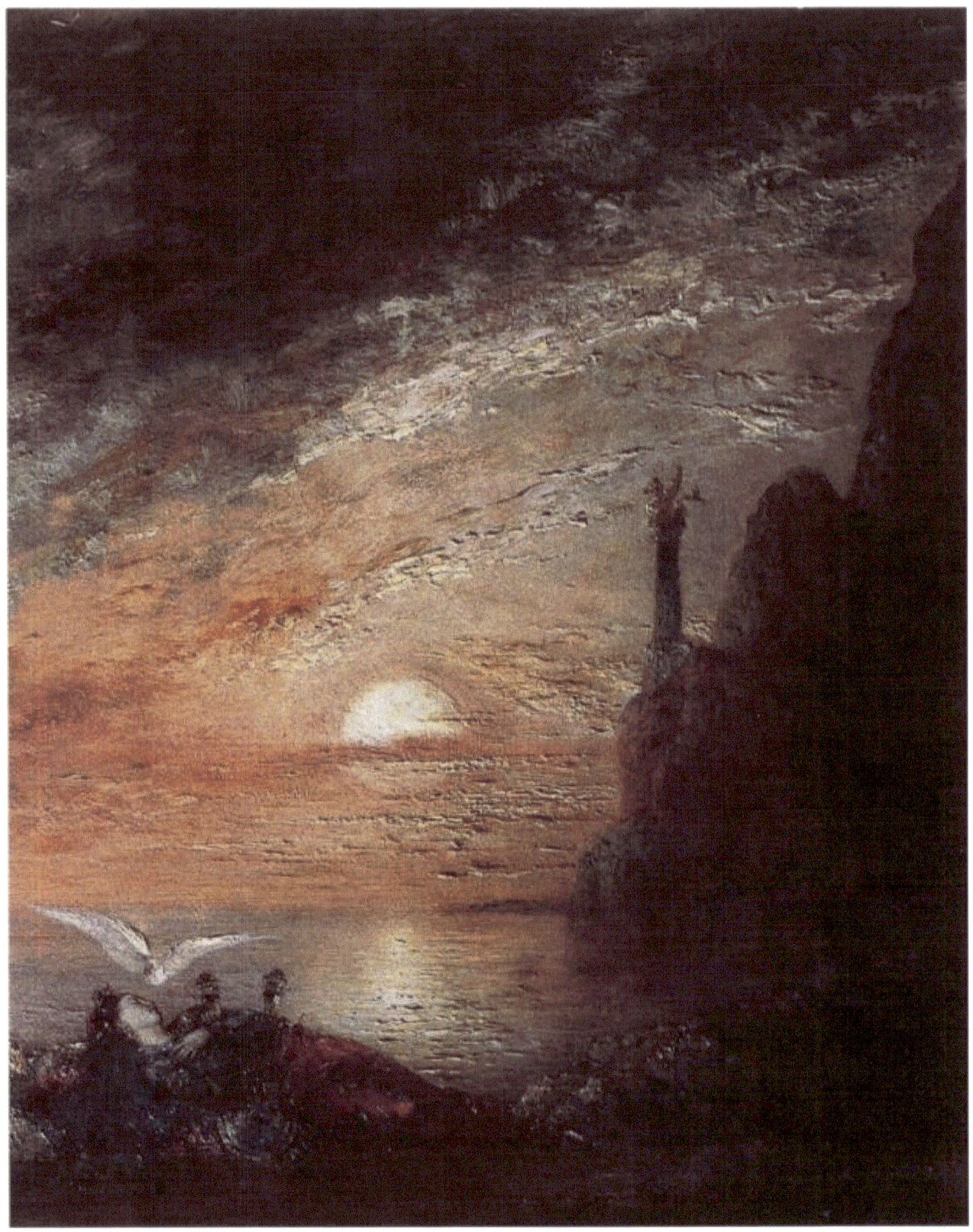

The Death of Sappho--Gustave Moreau--1876

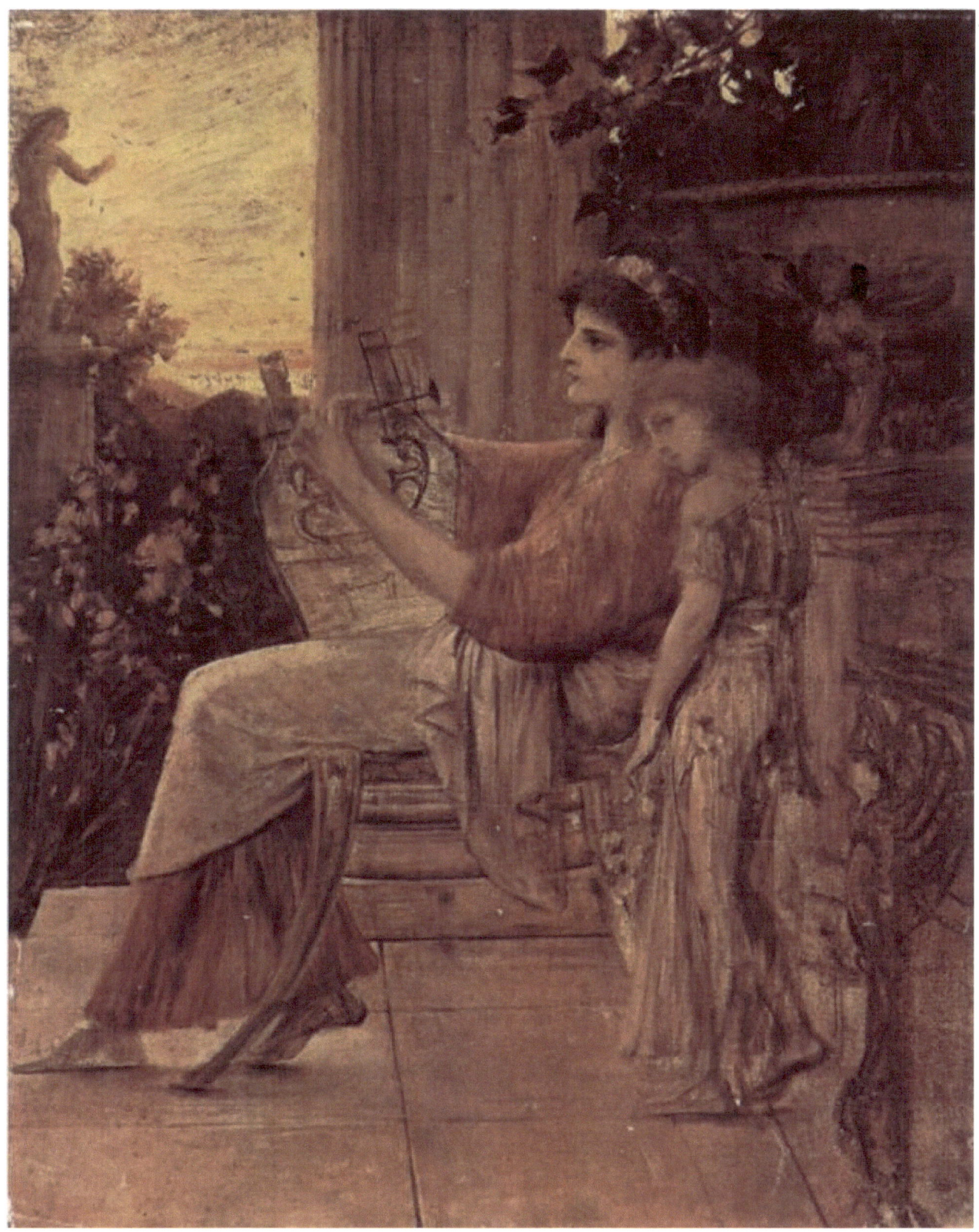

Sappho --Gustav Klimt --1890

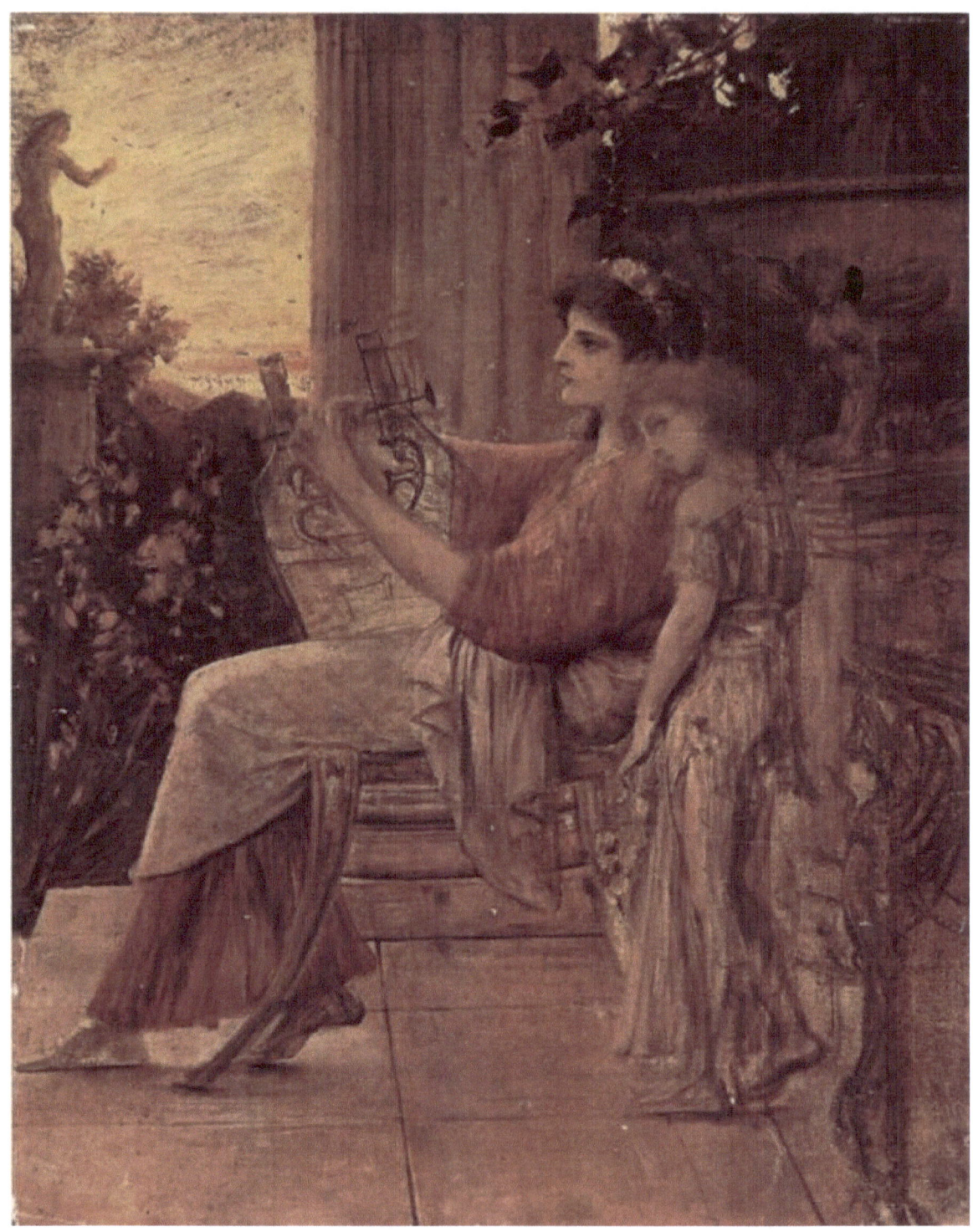

Sappho --Gustav Klimt --1890

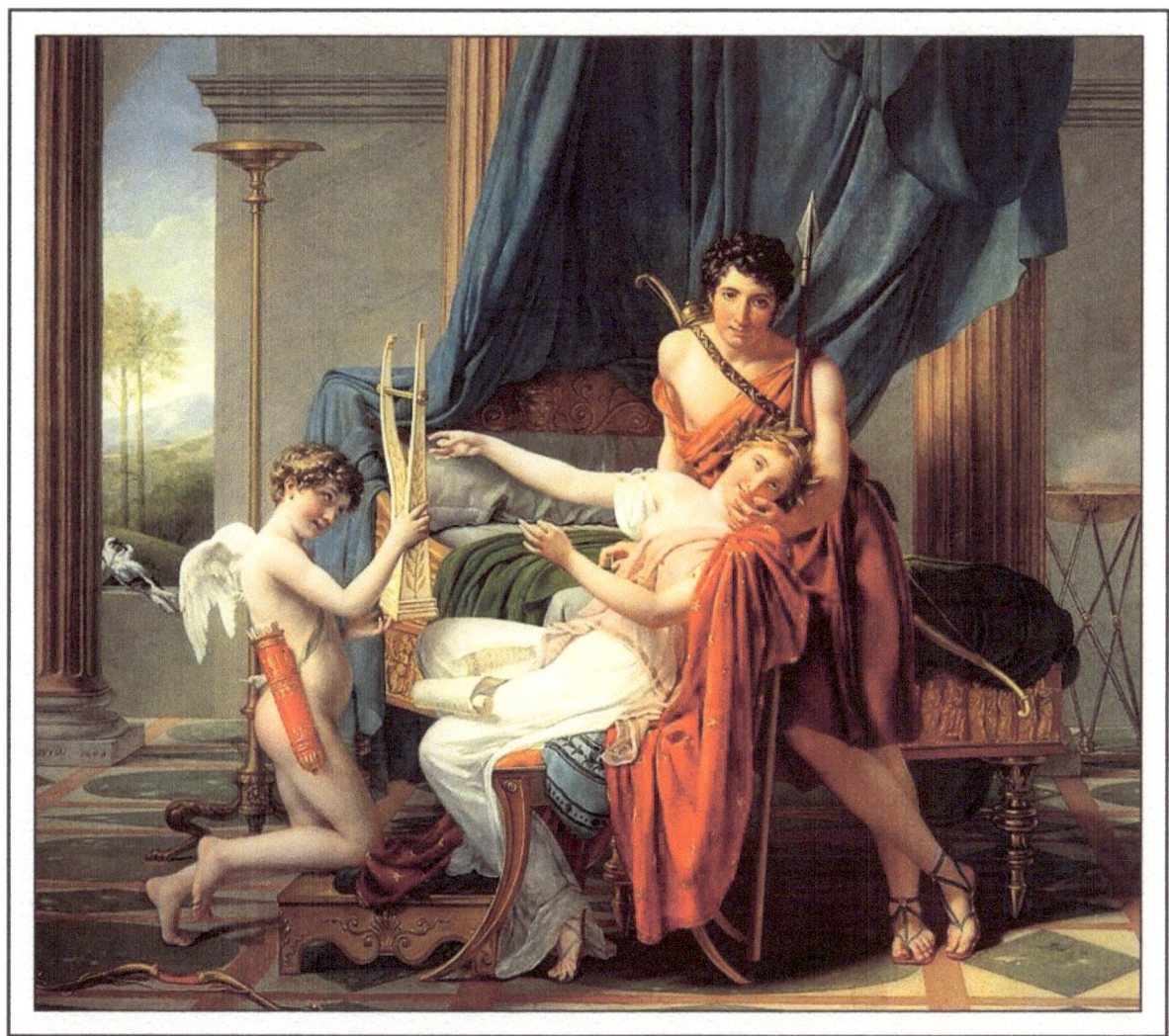

Sappho and Phaon--Jacques-Louis David—1809

EPITHALAMIUM

Vesper is here! behold
Faint gleams that welcome shine!
Rise from the feast, O youths,
And chant the fescennine!

Before the porch we sing
The hymeneal song;
Vesper is here, O youths!
The star we waited long.

We lead the festal groups
Across the bridegroom's porch;
Vesper is here, O youths!
Wave high the bridal torch.

Hail, noble bridegroom, hail!
The virgin fair has come;
Unlatch the door and lead
Her timid footsteps home.

Hail, noble bridegroom, hail!
Straight as a tender tree;
Fond as a folding vine
Thy bride will cling to thee.

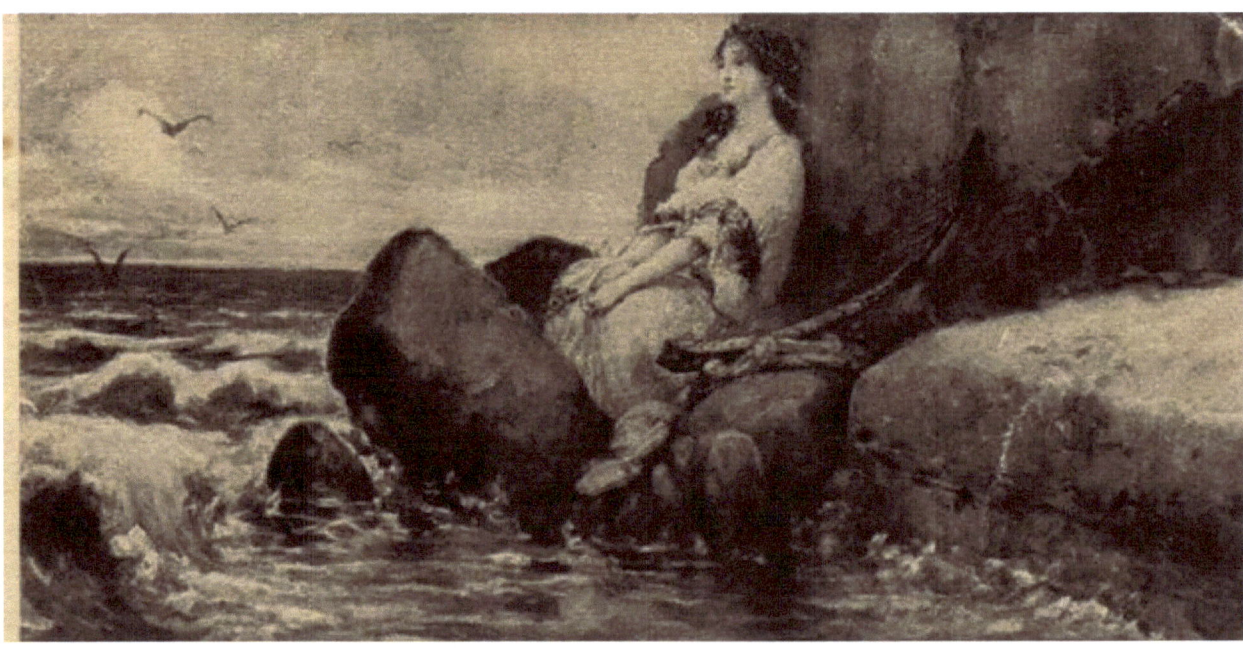

Sappho-- Wilhelm Kotarbinski

THE STRICKEN FLOWER

Think not to ever look as once of yore,
Atthis, upon my love; for thou no more
Wilt find intact upon its stem the flower
Thy guile left slain and bleeding in that hour.

So ruthless shepherds crush beneath their feet
The hill flower blooming in the summer heat;
The hyacinth whose purple heart is found
Left bruised and dead, to darken on the ground.

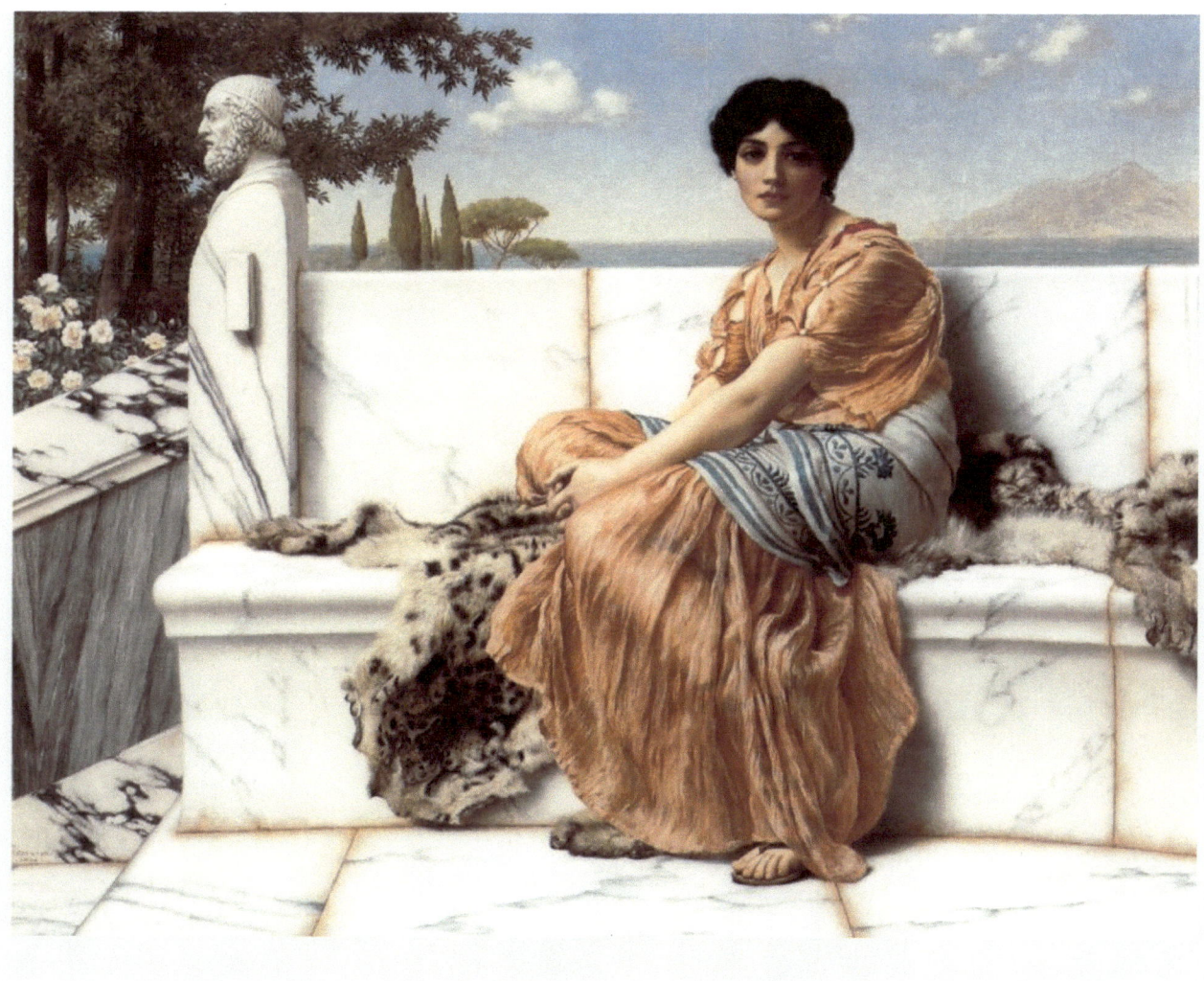

In the Days of Sappho --John William Godward --1904

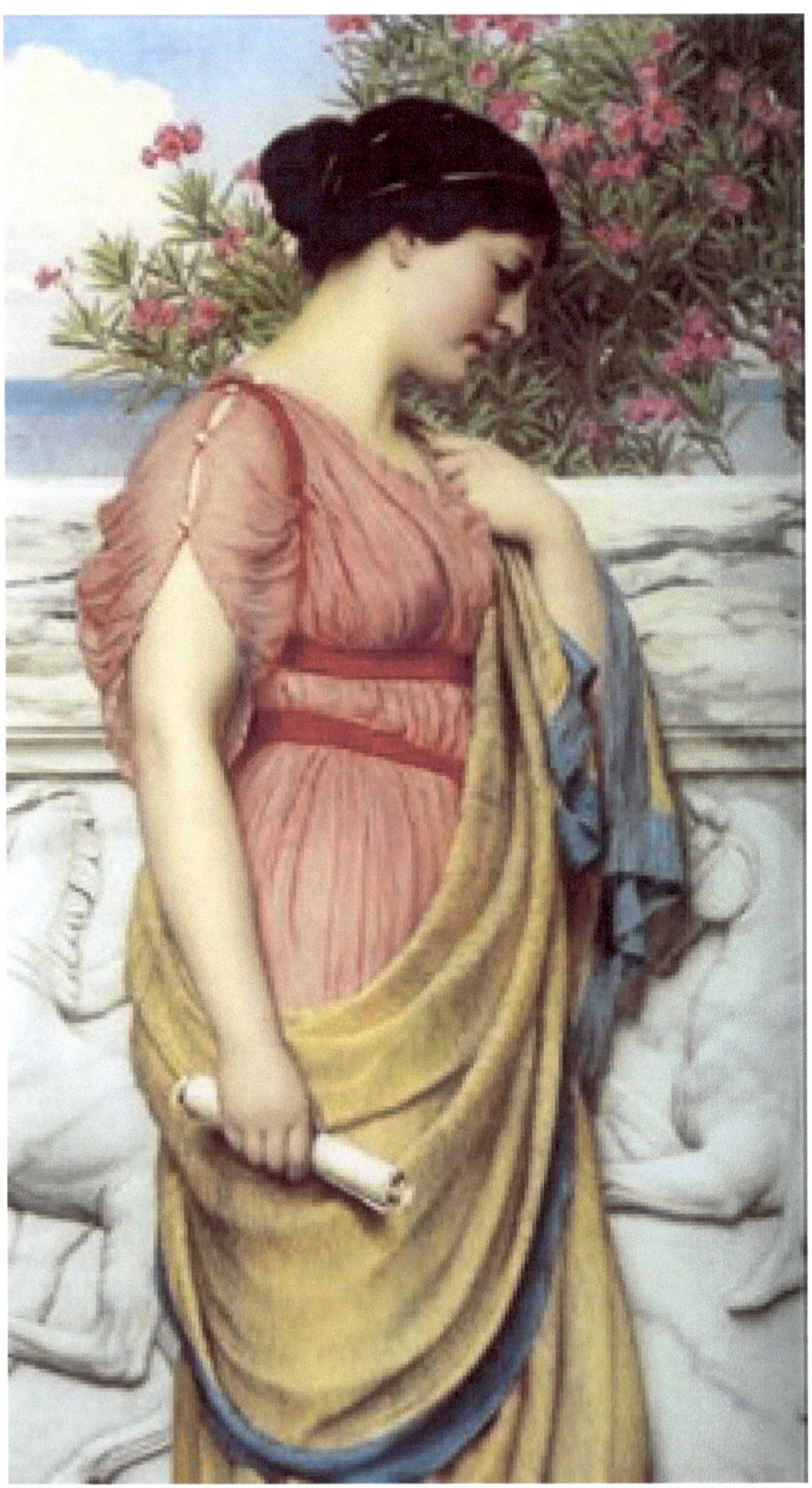

Sappho -- John William Godward -- 1910

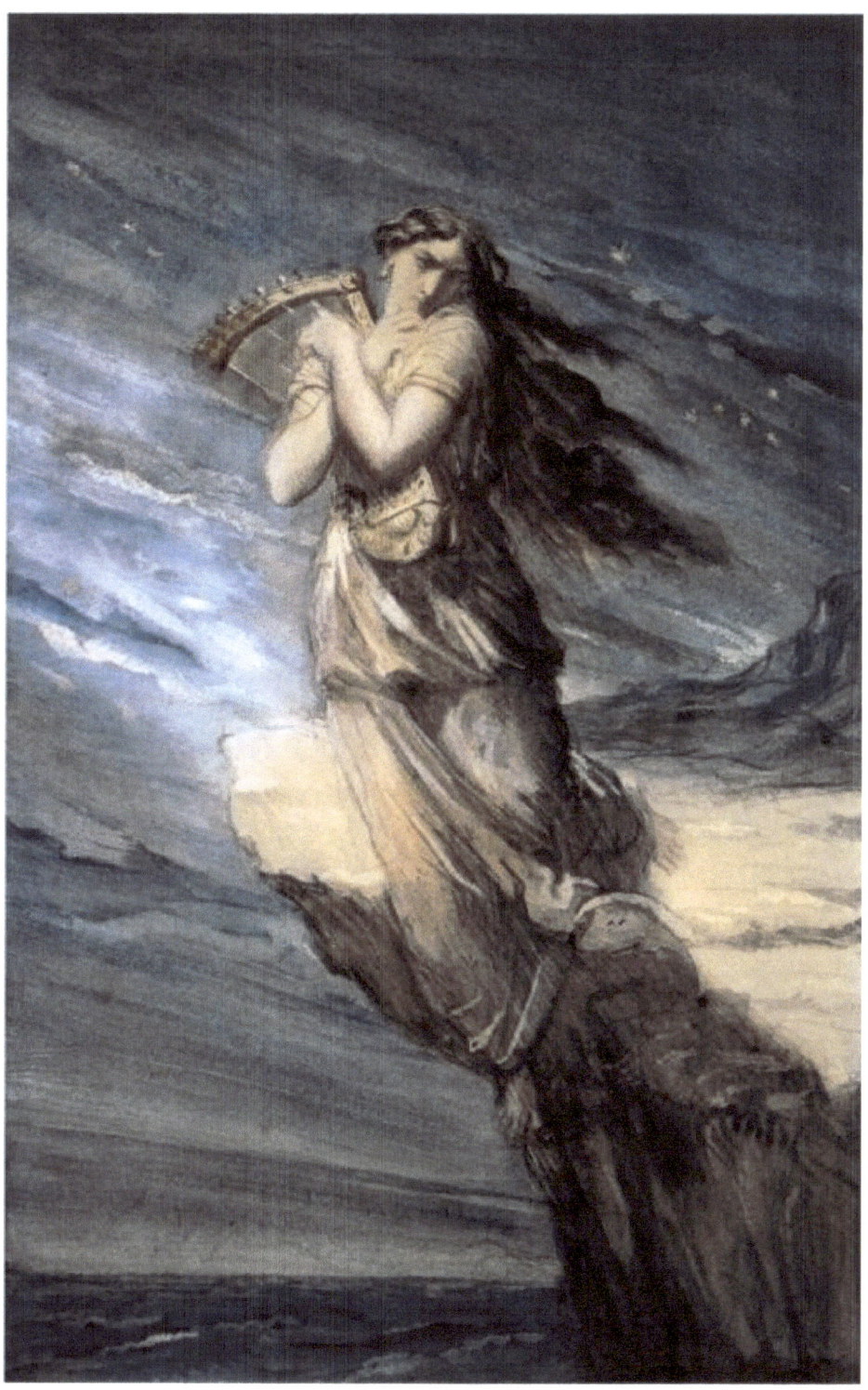

Sappho Leaping into the Sea from the Leucadian Promontory

Theodore Chasseriau --1840

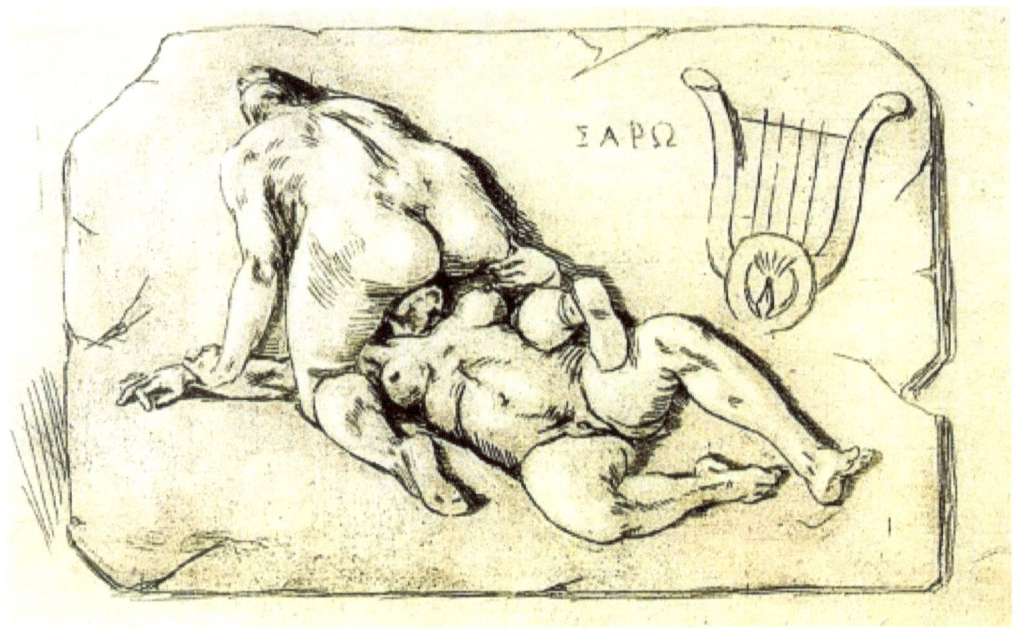

Lesbos, Known as Sappho-- Felicien Rops –1890

THE DAUGHTER OF CYPRUS

Dreaming I spake with the Daughter of Cyprus,
Heard the languor soft of her voice, the blended
Suave accord of tones interfused with laughter
Low and desireful;

Dreaming saw her dread ineffable beauty,
Saw through texture fine of her clinging tunic
Blush the fire of flesh, the rose of her body,
Radiant, blinding;

Saw through filmy meshes the melting lovely
Flow of line, the exquisite curves, whence piercing
Rapture reached with tangible touch to thrill me,
Almost to slay me;

Saw the gleaming foot, and the golden sandal
Held by straps of Lydian work thrice doubled
Over the instep's arch, and up the rounded
Dazzling ankle;

Saw the charms that shimmered from knee to shoulder,
Hint of hues, than milk or the snowdrift whiter;
Secret grace, the shrine of the soul of passion,
Glows that consumed me;

Saw the gathered mass of her xanthic tresses,
Mitra-bound, escape from the clasping fillet,
Float and shine as clouds in the sunset splendor,
Mists in the dawn-fire;

Saw the face immortal, and daring greatly,
Raised my eyes to hers of unfathomed azure,
Drank their world's desire, their limitless longing,
Swooned and was nothing.

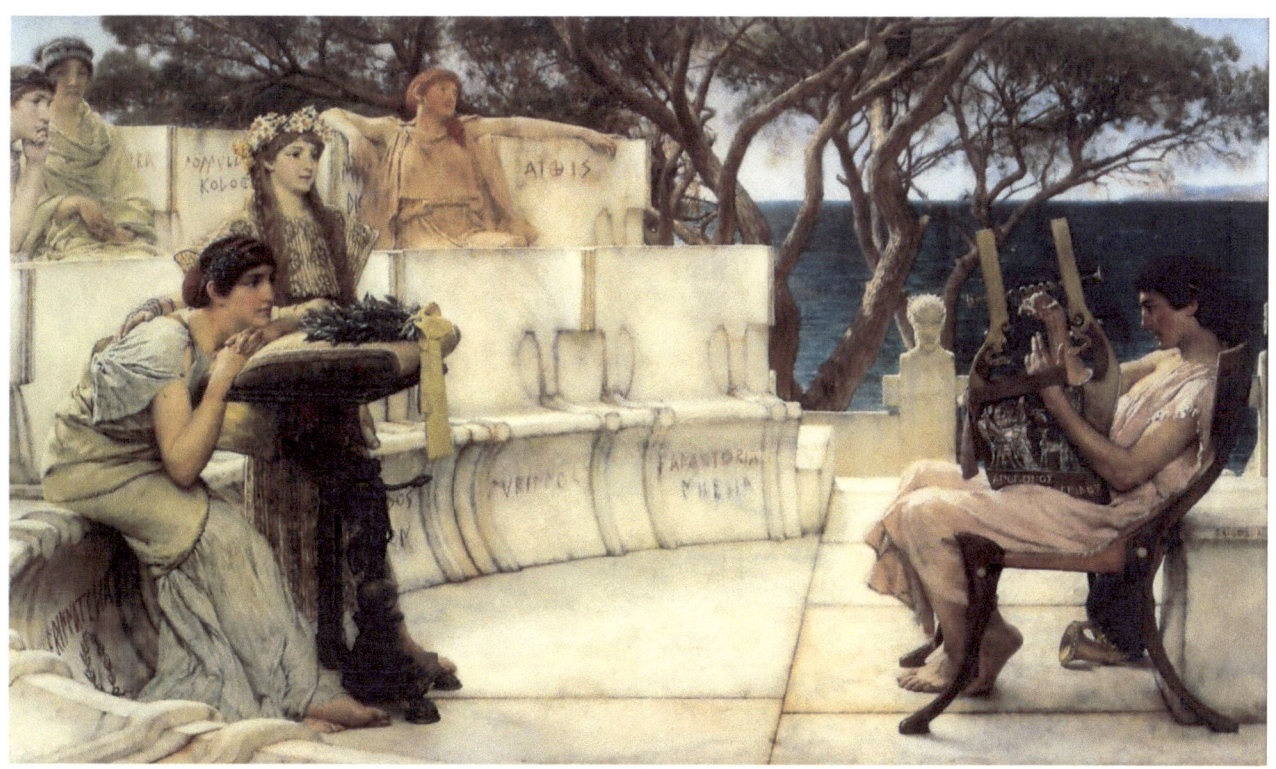

Sappho and Alcaeus -- Sir Lawrence Alma-Tadema--1881

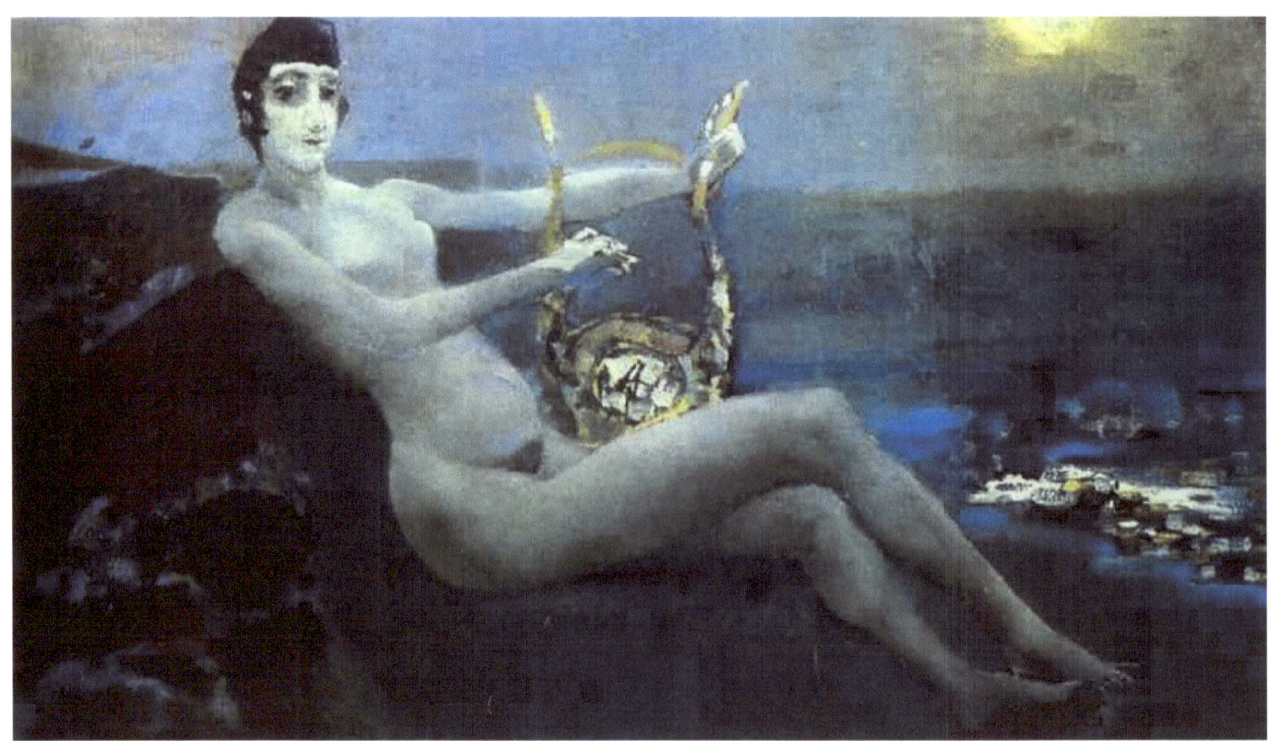

Sappho -- Mikhail Vrubel –1885

BRIDAL SONG

Bride, that goest to the bridal chamber
In the dove-drawn car of Aphrodite,
By a band of dimpled
Loves surrounded;

Bride, of maidens all the fairest image
Mitylene treasures of the Goddess,
Rosy-ankled Graces
Are thy playmates;

Bride, O fair and lovely, thy companions
Are the gracious hours that onward passing
For thy gladsome footsteps
Scatter garlands.

Bride, that blushing like the sweetest apple

On the very branch's end, so strangely
Overlooked, ungathered
By the gleaners;

Bride, that like the apple that was never
Overlooked but out of reach so plainly,
Only one thy rarest
Fruit may gather;

Bride, that into womanhood has ripened
For the harvest of the bridegroom only,
He alone shall taste thy
Hoarded sweetness.

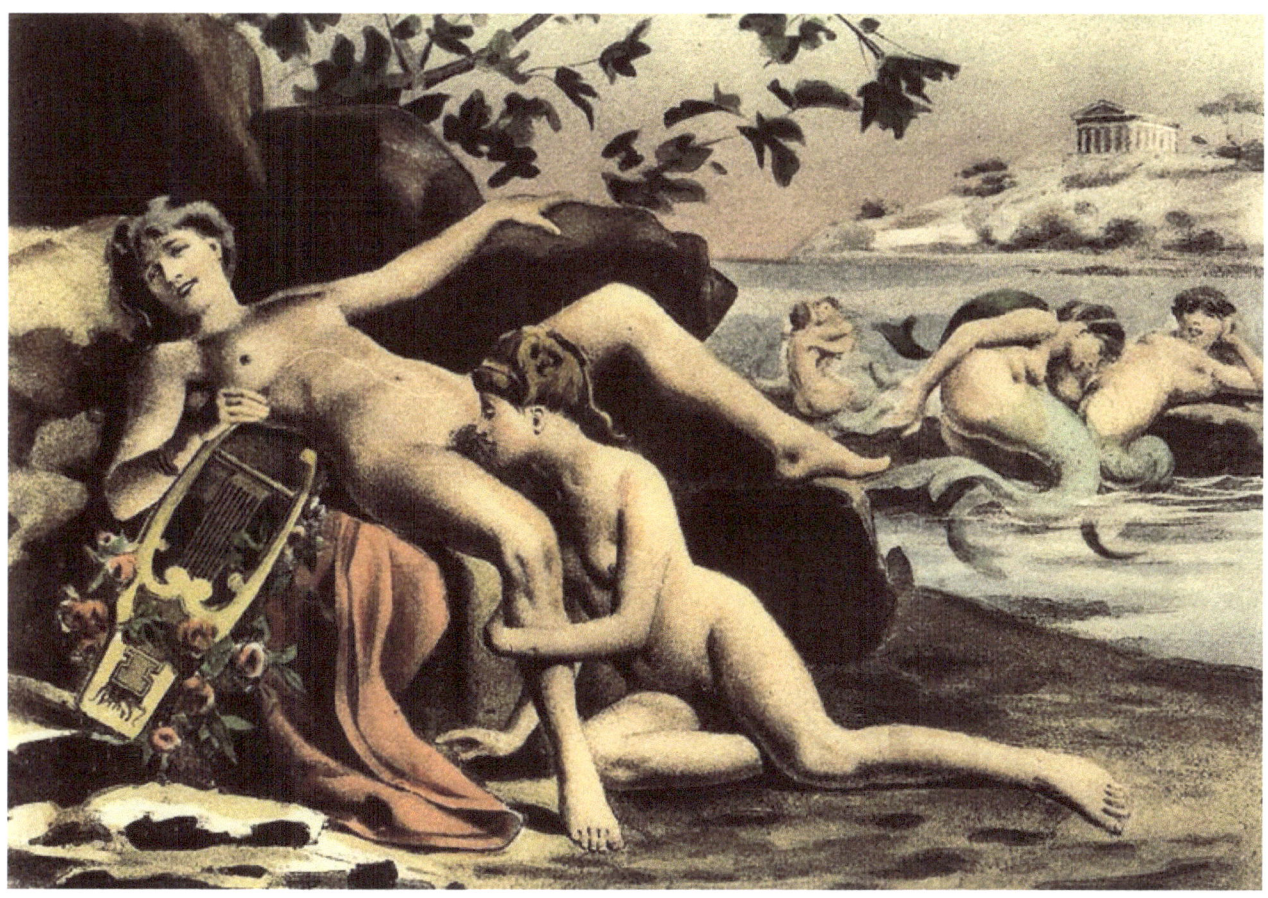

Sappho and friends-- eroticist Édouard-Henri Avril

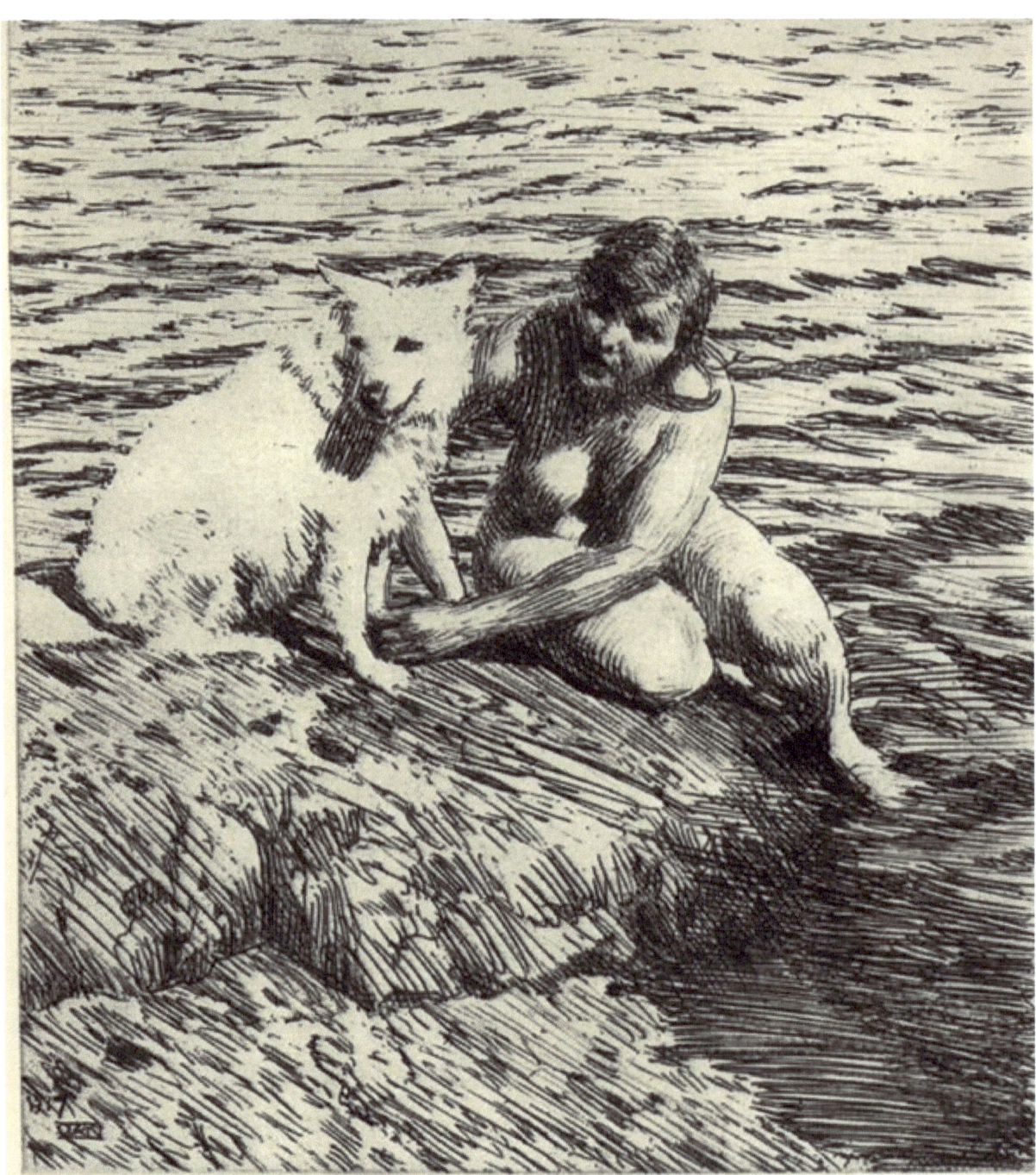

Sappho -- Anders Zorn --1917

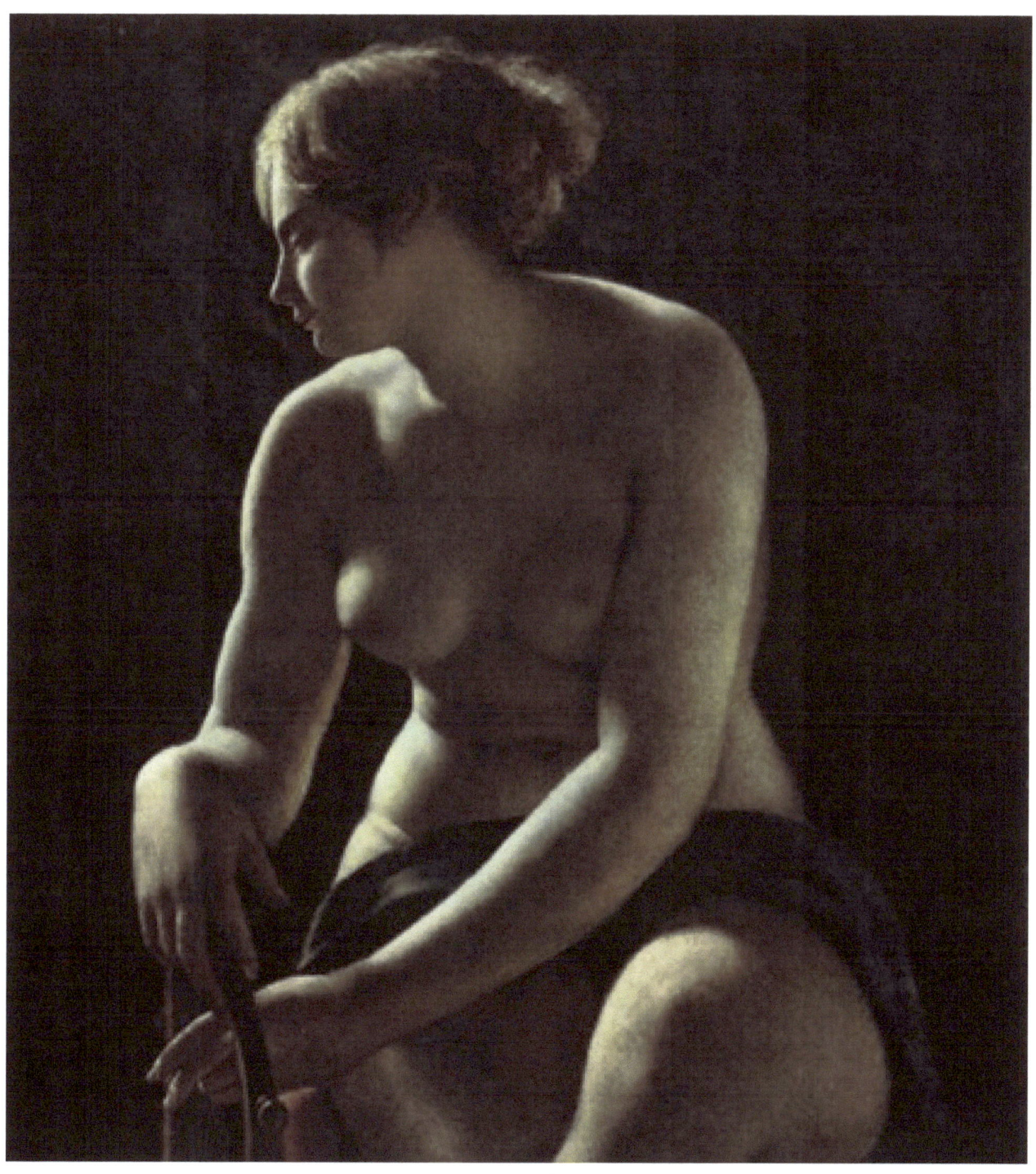

Sappho -- Pierre-Narcisse Guerin

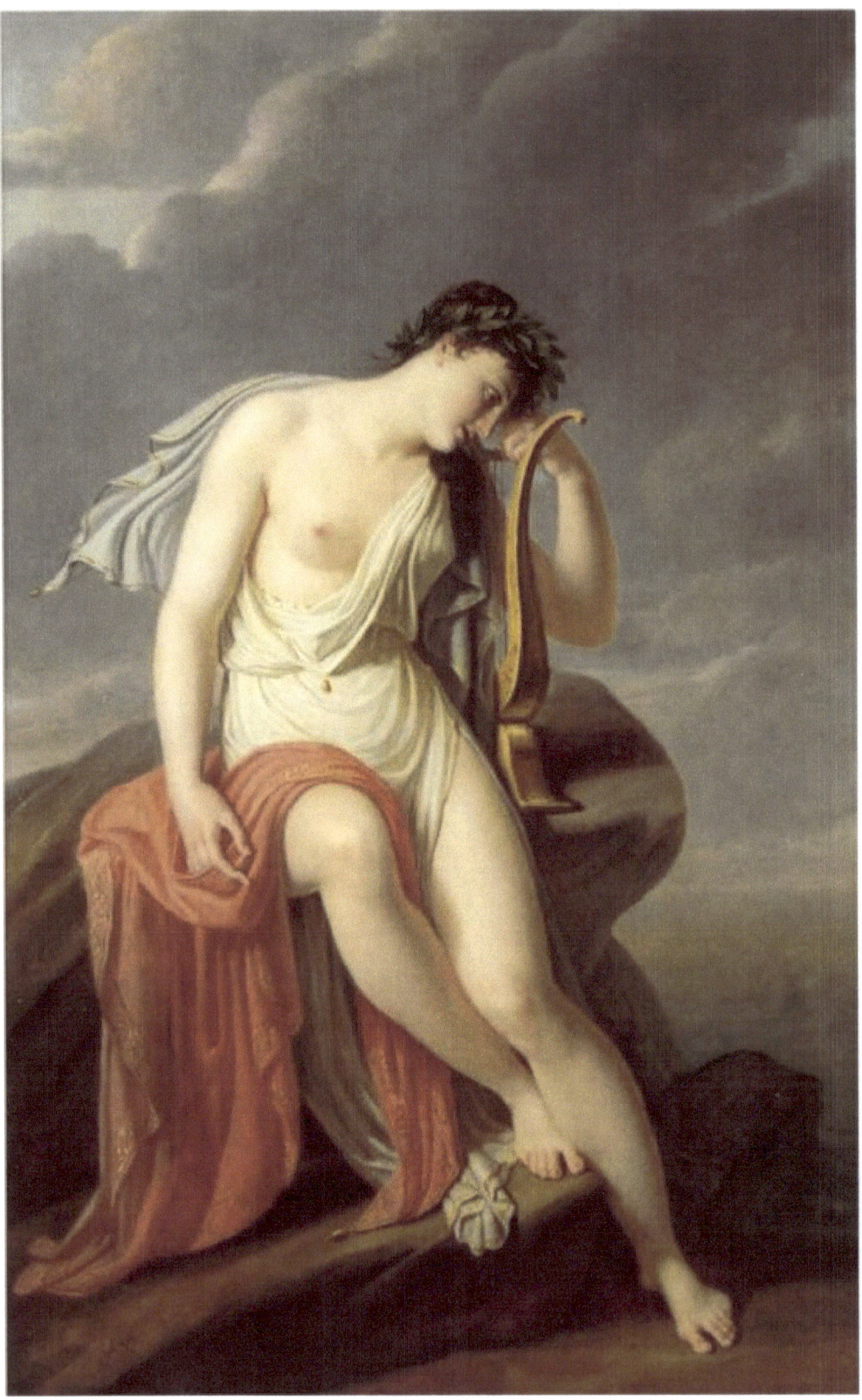

Sappho on the Leucadian Cliff --Pierre-Narcisse Guerin